A Modern
Garden

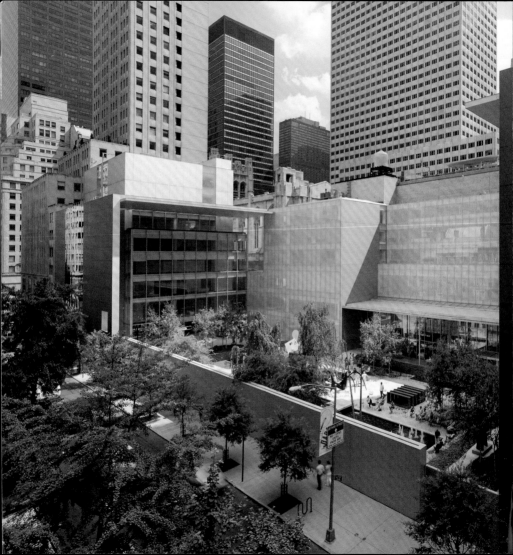

A Modern Garden

The Abby Aldrich Rockefeller Sculpture Garden at The Museum of Modern Art

The Museum of Modern Art, New York

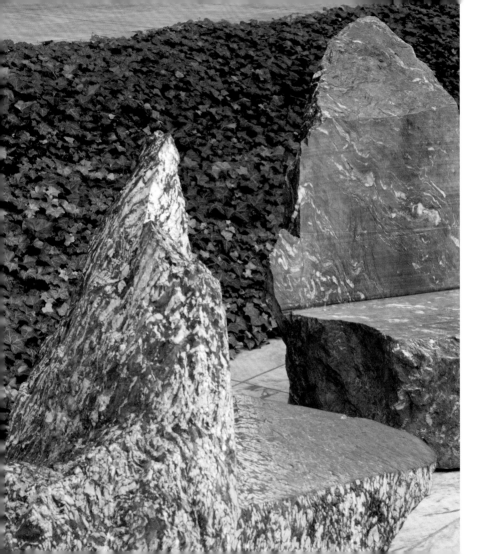

This book is dedicated to
the memory of Jane Meyerhoff
by Agnes Gund and Daniel Shapiro

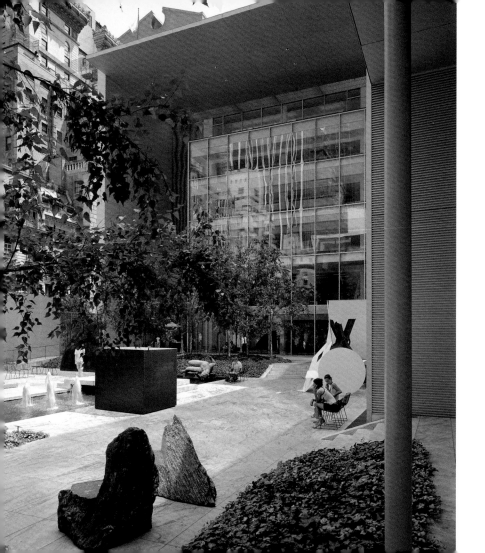

Foreword

The Abby Aldrich Rockefeller Sculpture Garden lies at the heart of The Museum of Modern Art. Dedicated in 1953 in memory of Mrs. John D. Rockefeller, Jr., one of the founders of the Museum, this oasis in midtown Manhattan serves as a spectacular setting for visitors to enjoy art in the outdoors. Seasonal plantings, reflecting pools, and masterworks of modern sculpture welcome visitors to the garden. Over many decades, numerous special exhibitions, concerts, and festive social events have also taken place in this memorable outdoor space, making MoMA's Sculpture Garden a vital and cherished part of New York's urban life.

This publication celebrates a most important landmark in modern urban garden design. The Sculpture Garden as we now know it was created by the gifted architect Philip Johnson, who was intimately involved with the Museum since shortly after its founding. When Yoshio Taniguchi designed the Museum's recent expansion that was completed in 2004, he reinforced the garden as the center of the entire complex. Taniguchi's minimalist glass facades, which elegantly and effectively frame the garden, allow us to experience the sense of flowing space between indoors and outdoors—a quintessential modernist concept that is integral to the Museum's architecture and in turn underscores the Sculpture Garden as one of the most distinctive elements of the Museum today.

—*Glenn D. Lowry, Director, The Museum of Modern Art*

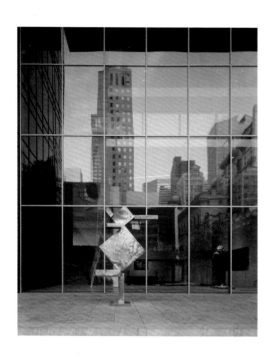

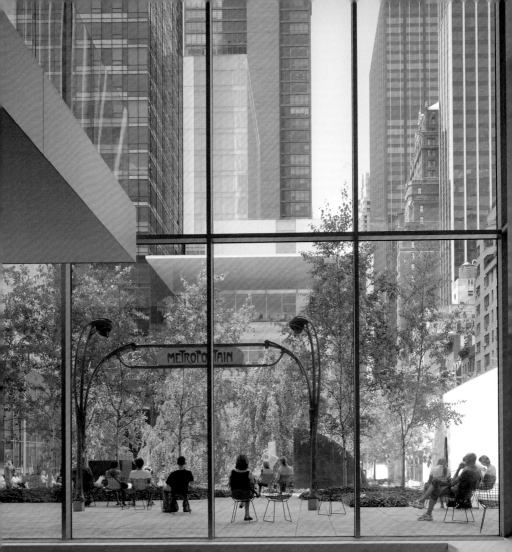

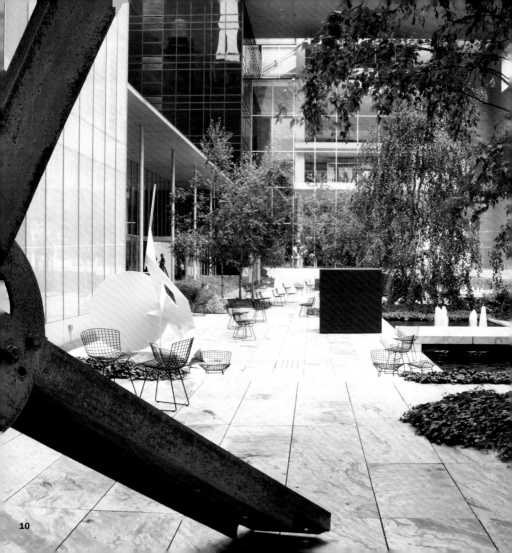

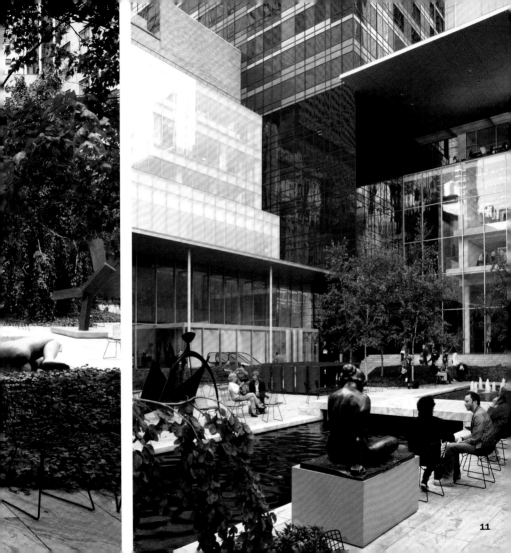

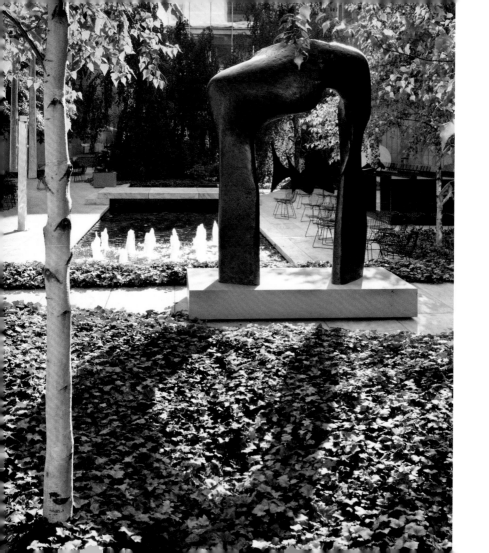

MoMA's Outdoor Room

Peter Reed

When The Museum of Modern Art opened its first sculpture garden in 1939, it inaugurated a new concept that would become an essential element for many modern art museums—an outdoor gallery for changing installations of sculpture. The opportunity to create the garden was made possible when John D. Rockefeller, Jr. donated to the Museum several properties on West Fifty-fourth Street. This extraordinary philanthropic act gave visitors the rare pleasure of experiencing art in relation to the sky, sun, and nature. The gift was also one of great civic dimension, providing a dense urban metropolis with a welcome oasis in the heart of the city.

The original garden was created to complement the Museum's first permanent home. This "happy improvisation," as it has been called, was designed by Alfred H. Barr, Jr., the Museum's first director, and John McAndrew, Curator of Architecture, just a few short weeks before the Museum's gala opening. It was inspired by the organic shapes seen in

Surrealist art, intended to contrast with the precise, rectangular geometries of the Museum's architecture and the city's unrelenting grid. The garden proved enormously successful, providing an opportunity for aesthetic pleasure in contemplating the art as well as a lively social scene.

By the late 1940s, the Museum recognized the need for a more permanent sculpture garden. Philip Johnson—MoMA's renowned curator, patron, and a gifted architect—was commissioned to design the new garden, which opened in 1953 and was dedicated to Abby Aldrich Rockefeller, one of three founders of the Museum and the wife of John D. Rockefeller, Jr. The garden we know today is a restoration of Johnson's design, which remains one of the Museum's most admired spaces.

Johnson said that his "conception was a piazza...a sort of outdoor room." This succinct description, however, belies the many sources that informed his design: Japanese gardens, the architecture of the great German émigré Ludwig Mies van der Rohe, the water features of Moorish gardens, and the great squares of Italy. In particular, Johnson admired the Piazza San Marco in Venice, as much for its architecture as for its role in the vibrant life of the city. Just as San Marco lies at the heart of Venice, the Sculpture Garden is central to MoMA's campus. For more than five decades, Johnson's distinctive courtyard—paved in gray and white striated marble and enlivened by pools, groves of trees, beds of ivy, and seasonal plantings—has showcased masterpieces of the Museum's sculpture collection and hosted a wide array of memorable exhibitions and events.

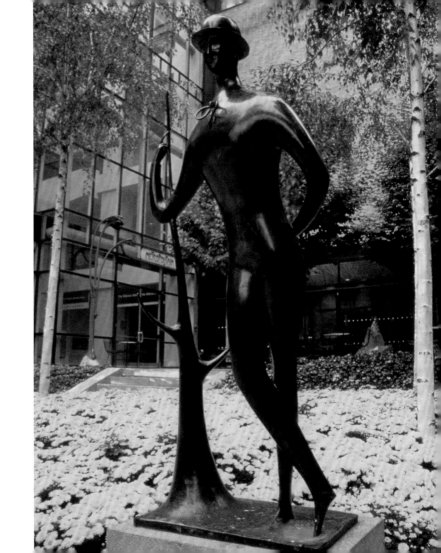

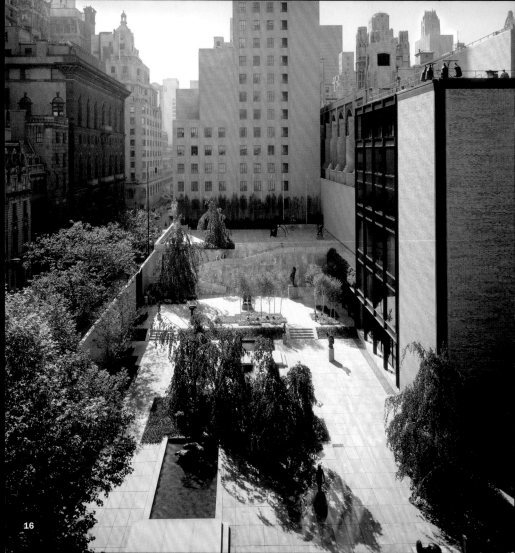

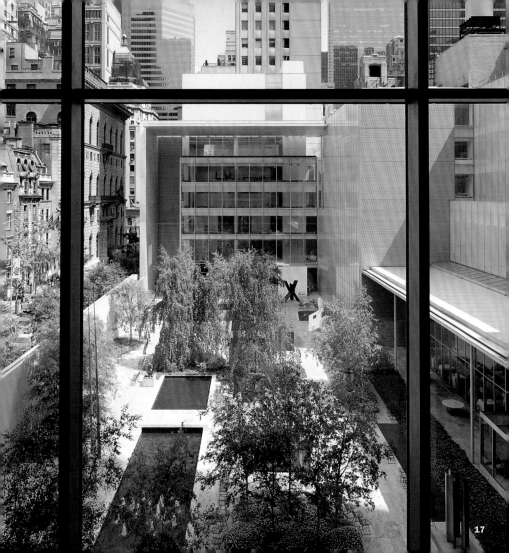

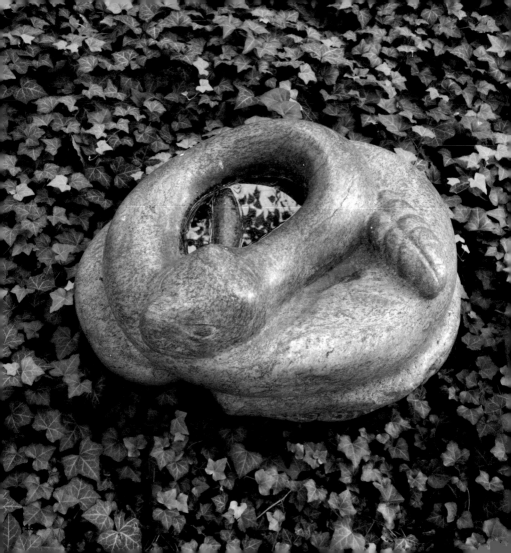

Johnson treated the rectangular plot of the garden in a manner befitting its urban setting. The walled courtyard is sunken several feet below street level and surrounded by terraces that abut the Museum building. The gridded pattern of the marble pavement is bisected by two pools. Tall weeping beeches with gnarled limbs occupy the center, and subsidiary groves of birch trees further articulate the space into four main areas and direct the visitor's path of movement around the garden and over the footbridges. The plantings, originally developed with landscape architect James Fanning and subsequently with Zion Breen & Richardson Associates, serve as screening devices and backdrops for the works of art.

For a garden to serve as a place to look at art, one of the principal challenges is to create the spatial equivalents of interior galleries. The garden and its sculpture are revealed progressively, and visitors must circulate through the various spaces and settings in order to experience the whole. While Johnson anticipated the path of the visitors' feet and eyes, the selections of works are not usually conceived in any narrative or chronological thread. Rather, the changing installations offer a series of encounters wherein sculptures are seen in isolation and in counterpoint with each other.

From the early years of the Sculpture Garden, the works on view were primarily figurative and life-size. These works are particularly well suited to Johnson's design and, over the years, a number of them have become inextricably linked with MoMA's garden. Among these masterworks are Gaston Lachaise's *Standing Woman* (1932), a monumental glorification of

the human body; Aristide Maillol's *The Mediterranean* (1902–05), an idealized woman in contemplative repose; and Maillol's *The River* (1938–43), a falling figure effectively installed above one pool's surface. Figurative sculptures in cast bronze by Auguste Rodin, Henri Matisse, Henry Moore, and other modern artists are also frequently on view and illustrate remarkable innovations within this tradition.

Since The Abby Aldrich Rockefeller Sculpture Garden opened, the collection has grown with the addition of representational and abstract works, revealing many of the radical changes that took place in twentieth-century sculpture. Formal developments in abstraction and technical innovations in fabrication, such as welded metal and other nontraditional mediums, pushed the boundaries of what sculpture could be. Well known for his "mobiles," Alexander Calder's static sculptures, or "stabiles," are particularly effective for outdoor settings, exemplified by his creeping *Black Widow* (1959), constructed of painted pieces of sheet steel bolted together. Anthony Caro's *Midday* (1960), an amalgam of industrial parts painted bright yellow, provides a chromatic and spatial counterpoint to David Smith's burnished stainless steel surfaces of *Cubi X* (1963), a composition of geometric cubes that seems to suggest a figure. Some works displayed in the garden introduce a sense of whimsy. Pablo Picasso's *She-Goat* (1950), cast from an assemblage of earthenware jugs, a palm leaf, a wicker basket, and other found objects, is humorous for its subject and its method of fabrication. Claes Oldenburg's *Geometric Mouse, Scale A* (1975), composed of circles

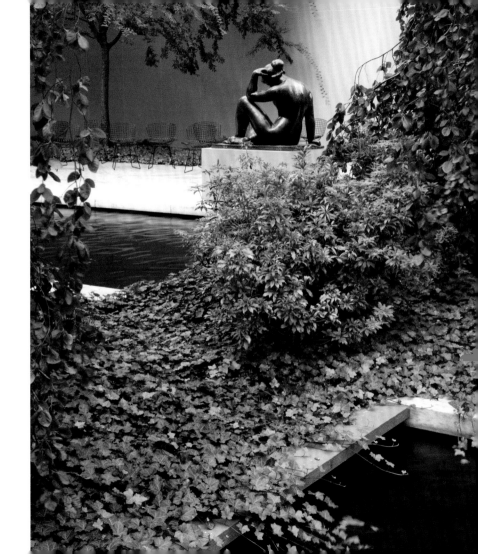

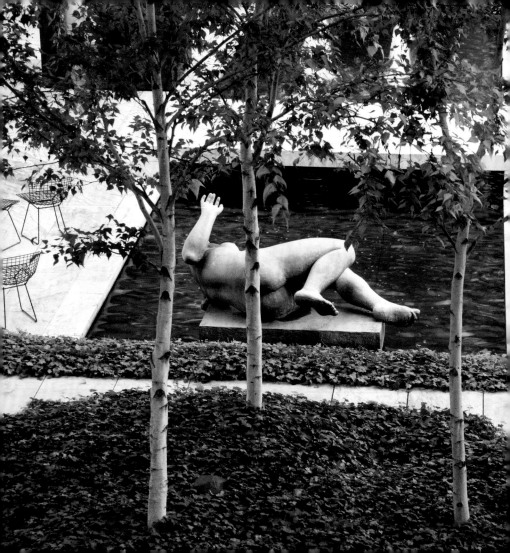

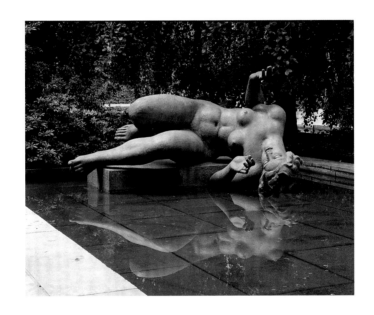

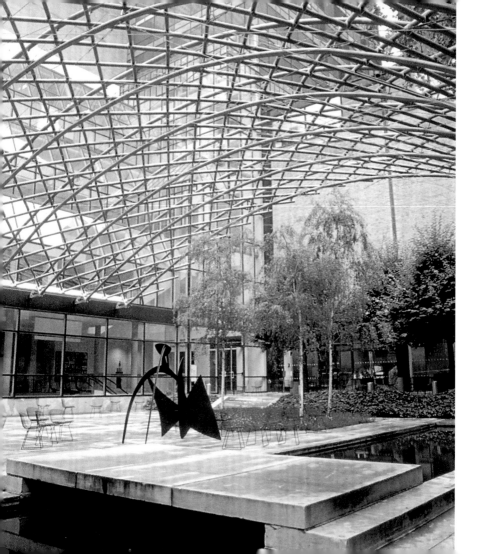

and squares, also describes the simplified form of a monumental mouse head. Installing these robust, varied works requires a careful study of scale and siting—as much for the way the sculptures complement each other as for their relationship to their surroundings.

Throughout its history, the Sculpture Garden has also served as the setting for innovative temporary exhibitions and events. Automobile shows have demonstrated the beauty and engineering of what Arthur Drexler, Curator of Architecture, called "hollow rolling sculpture"; in 1960, Jean Tinguely set in motion a self-destructing machinelike sculpture; in 1969, Yayoi Kusama staged an impromptu Happening with skinny-dipping conspirators; and, most recently, media artist Doug Aitken used the Museum's exterior walls as the screens for his film project *sleepwalkers*, for which the garden was free and open to the public after dark. The Museum has also exploited adjacent properties to present full-scale constructions of contemporary architecture. Exhibition houses designed by Marcel Breuer, Buckminster Fuller, and others have given visitors first-hand experience of these environments. Among the most spectacular of these was the construction in 1954 of a traditional seventeenth-century Japanese house and garden that demonstrated formal precedents in modern art and architecture. More recently, Shigeru Ban's breathtakingly beautiful pergola of paper tubes spanned the garden in an arc. The garden has also been the setting for a wide variety of artistic and social programs: the concerts devoted to jazz and new music of the nearly four-decade-old

Summergarden, dance performances, and popular social events have all contributed to fulfilling Johnson's vision for a piazza in Manhattan.

The central position occupied by the Sculpture Garden was recognized by Yoshio Taniguchi in his design for the new Museum that opened in 2004. While retaining Johnson's existing layout, he expanded the garden by extending its east and west terraces and framing them with two giant porticoes. These porticoes also allude to the traditional porches with overhanging, sheltering roofs from which one views Japanese gardens. The open space links the two halves of the Museum that reflect the institution's core commitment to education and research and to the exhibitions and public programs that result from them. Between these two wings, Taniguchi relocated the Museum's restaurant to open directly onto the garden's south terrace. Most telling of all, the remarkable transparency of Taniguchi's architecture is conducive to the free flow between interior and exterior from every floor, and it allows the viewer to embrace the farther horizon of the surrounding cityscape—the borrowed landscape—reinforcing the notion that the Museum and the garden are in some sense a microcosm of the city.

—Peter Reed is Senior Deputy Director for Curatorial Affairs

For Further Reading

Beneš, Mirka. "A Modern Classic: The Abby Aldrich Rockefeller Sculpture Garden." In *Philip Johnson and The Museum of Modern Art*. Studies in Modern Art 6. New York: The Museum of Modern Art, 1998.

Kassler, Elizabeth. "The Sculpture Garden." *MoMA: A Publication for Members of The Museum of Modern Art*, no. 4 (Summer 1975).

Modern Painting and Sculpture: 1880 to the Present at The Museum of Modern Art. Edited by John Elderfield. New York: The Museum of Modern Art, 2004.

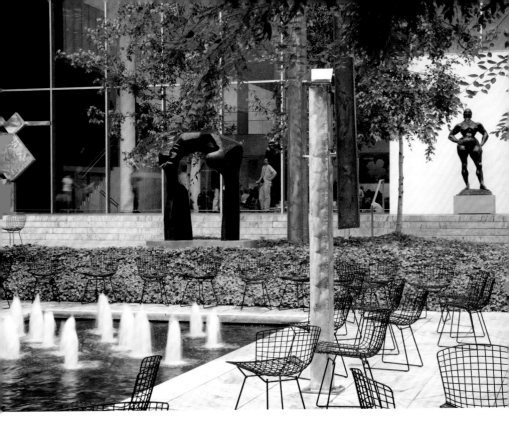

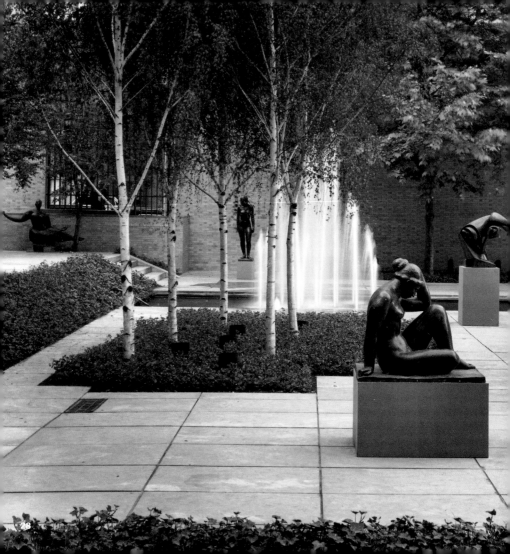

Highlights and Happenings
1939–2007

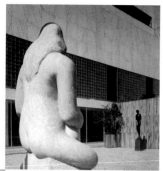

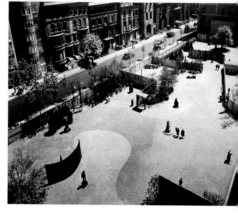

Abby Aldrich Rockefeller
(1874–1948), to whom
the garden was dedicated
in 1953

The Museum's first sculp-
ture garden, designed by
Alfred H. Barr, Jr. and John
McAndrew

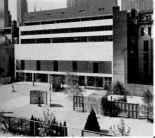

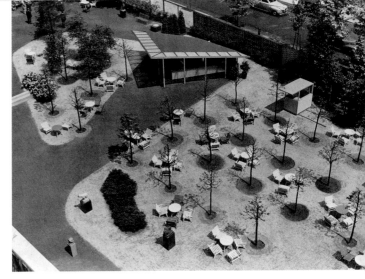

1939
View of the Museum and
garden from across West
Fifty-fourth Street

1942
Philip Goodwin modified the
garden with the addition of
a restaurant pavilion and a
grove of plane trees

31

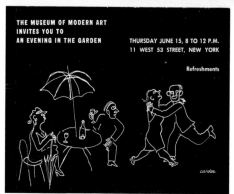

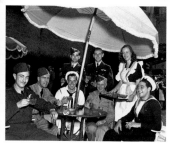

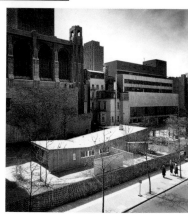

1942
Garden canteen for
servicemen

1944
Invitation designed by
Alexander Calder

1949
Marcel Breuer's House in the
Museum Garden

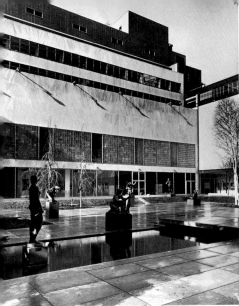

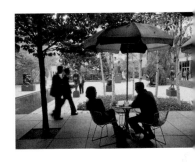

1953
The Abby Aldrich Rockefeller
Sculpture Garden, designed
by Philip Johnson

1953
View of the exhibition
Ten Automobiles

1953
Outdoor café

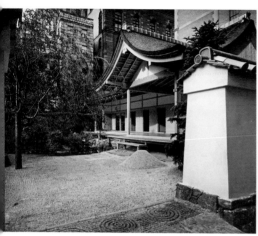

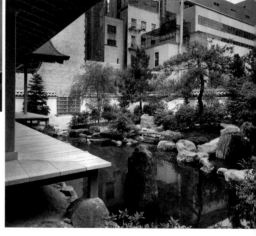

1954–55
Japanese Exhibition House,
on view in the garden in
1954 and 1955

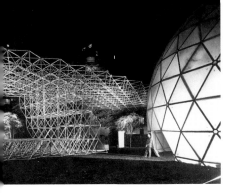

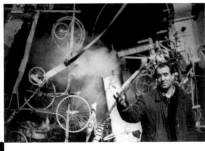

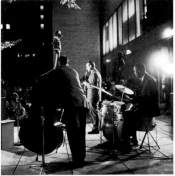

1959
View of the exhibition
*Three Structures by
Buckminster Fuller*

1960
The Jimmy Giuffre Quartet
performs for Jazz in the
Garden, in conjunction with
the exhibition *Jazz by Henri
Matisse*

1960
Jean Tinguely with his
"self-constructing and
self-destroying work of art"
Homage to New York as it
was set in motion

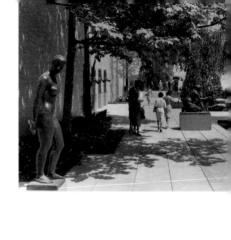

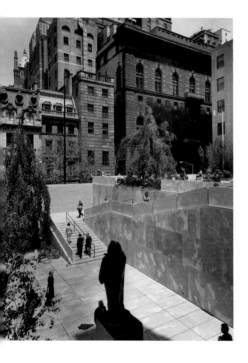

1964
The garden was enlarged
with the addition of an
upper terrace and grand
staircase designed by
Philip Johnson

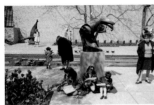

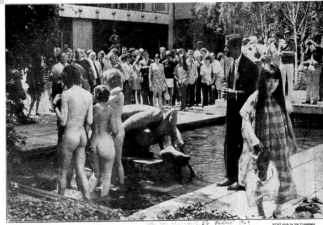

But Is It Art? Security officer Roy Williams pleads with nude young men and women to leave Museum of Modern Art fountain, where Maillol's sculpture, Girl Washing Her Hair, reclines. Impromptu nude-in was conception of Japanese artist Yayoi Kusama (right). Crowd takes it in stride. (Some took strides to get closer).
—*Story on page 4*

c. 1967
Schoolchildren sketching in
the Sculpture Garden

1969
Newspaper photograph
of Yayoi Kusama's sponta-
neous event "Grand Orgy
to Awaken the Dead at
MoMA"

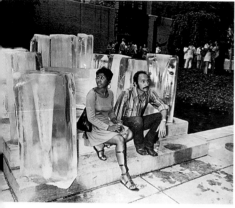

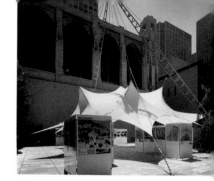

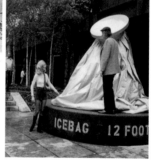

1970
MoMA Ice Piece, by Rafael
Ferrer, at the opening of
the exhibition *Information*.
Ferrer is seated on the
steps

1971
Claes Oldenburg installing
Ice Bag, Scale C as part
of *Technics and Creativity:
Selections from Gemini
G.E.L.*

1971
View of the exhibition
The Work of Frei Otto

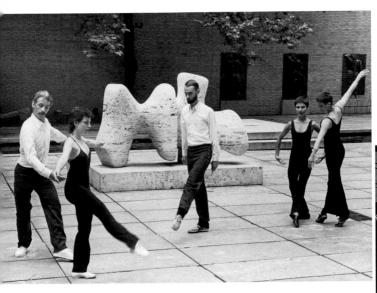

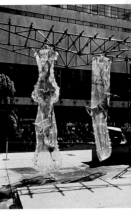

1971
Dancers perform at
Summergarden

1971
Multi-Gravitational
Experiment Group
rehearsal of a
Summergarden event

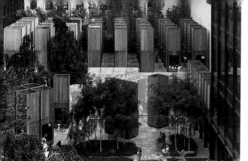

1972
View of the exhibition
*Italy: The New Domestic
Landscape*

1979
Film still from Woody Allen's
Manhattan (1979)

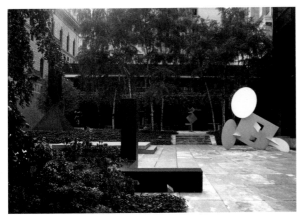

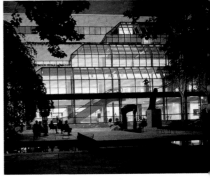

1984
View of the exhibition *Selections from the Permanent Collection: Painting and Sculpture*, with Tony Smith's *Free Ride* (1962) in the foreground, Barnett Newman's *Broken Obelisk* (1963–69) to the far left, and Claes Oldenburg's *Geometric Mouse, Scale A* (1975) to the far right

1984
Night view of the Museum's Garden Hall, part of an expansion designed by Cesar Pelli

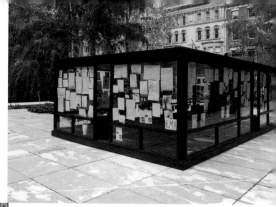

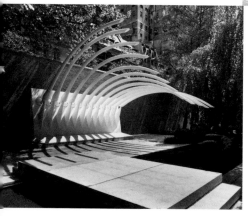

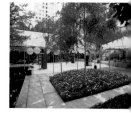

1993
A Machine for Making Shadows, a mechanized concrete sculpture from the exhibition *Santiago Calatrava: Structure and Expression*

1997
Rirkrit Tiravanija's child-size pavilion, inspired by Philip Johnson's Glass House (1949), part of the exhibition *Projects 58*

1998
Preparations for Party in the Garden, an annual gala

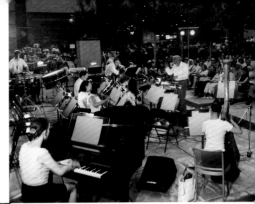

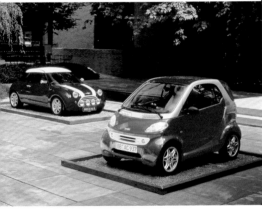

1999
View of the exhibition
Different Roads:
Automobiles for the
Next Century

1999
Musical performance
in conjunction with
Summergarden

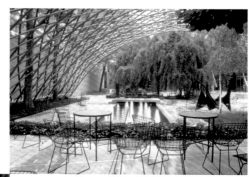

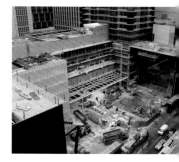

2000
Piotr Uklanski's illuminated
Dance Floor, part of the
exhibition *Projects 72*

2000
View of the exhibition
Shigeru Ban: A Paper Arch

2003
View of the construction
of the new Museum
expansion, designed by
Yoshio Taniguchi

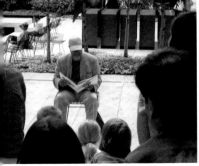

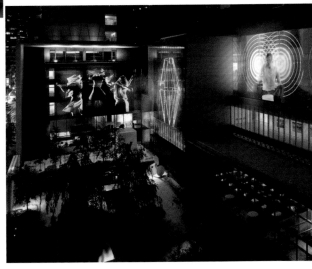

2006
Artist Jerry Pinkney
reading to children and
their families

2007
View of Doug Aitken's
sleepwalkers projected
on the Museum's exterior
walls

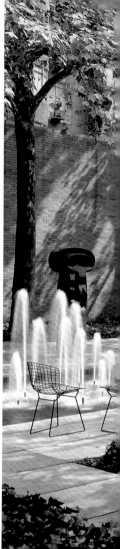

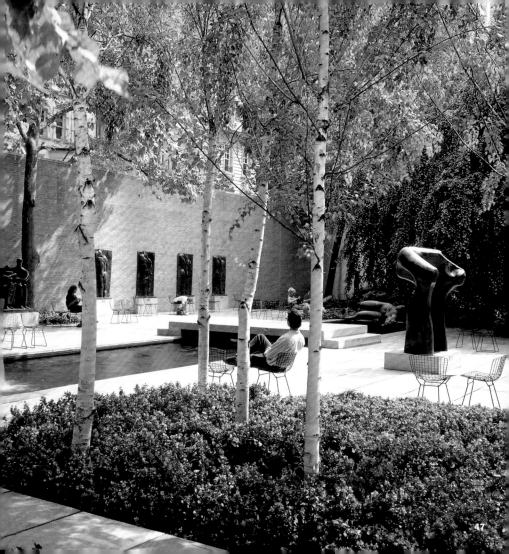

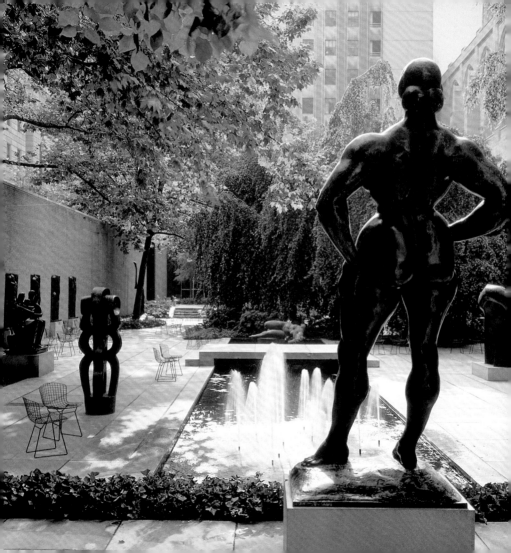

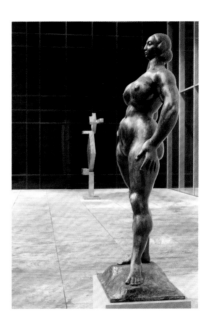

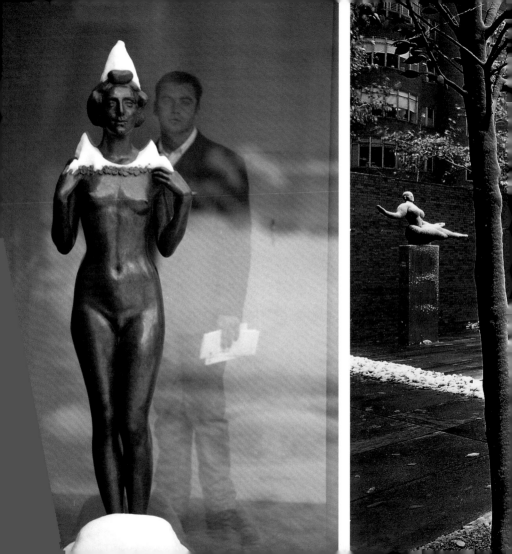

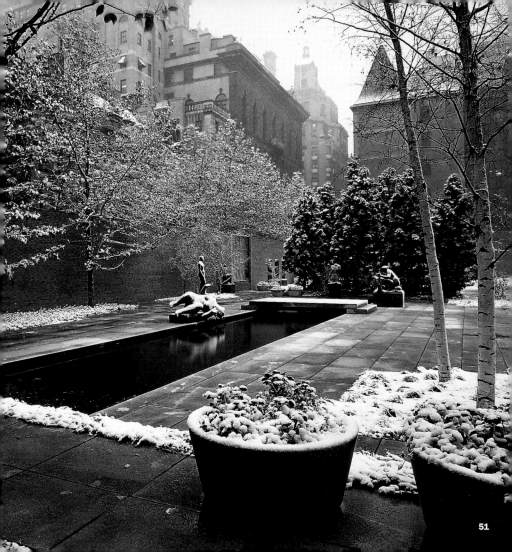

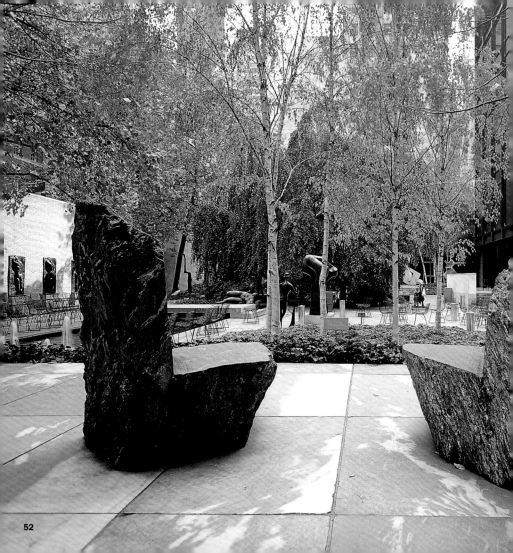

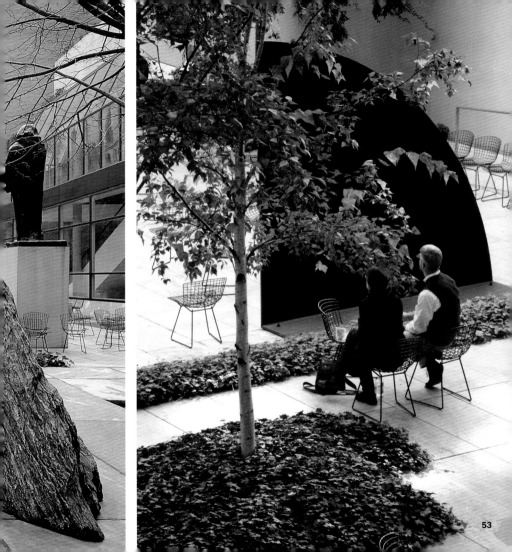

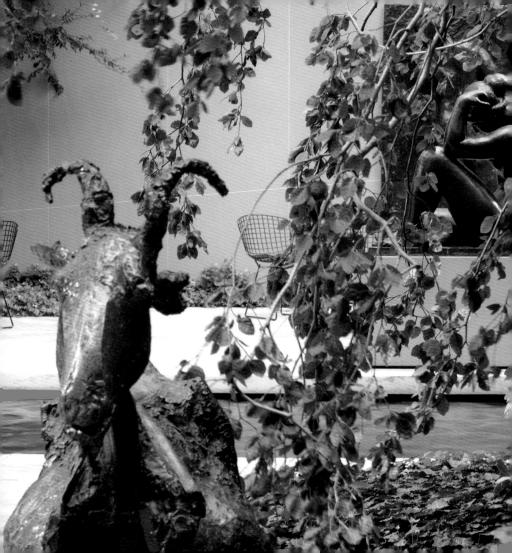

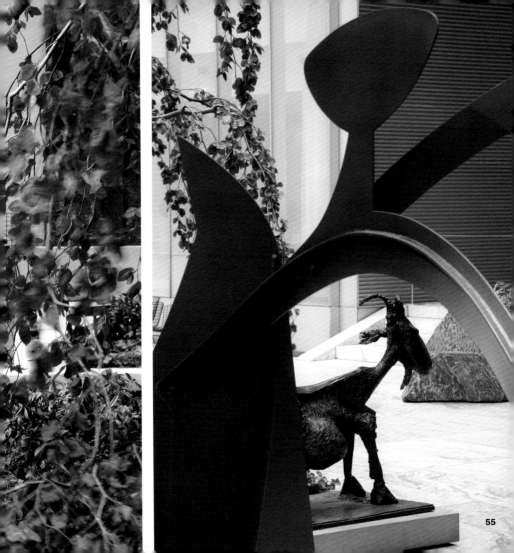

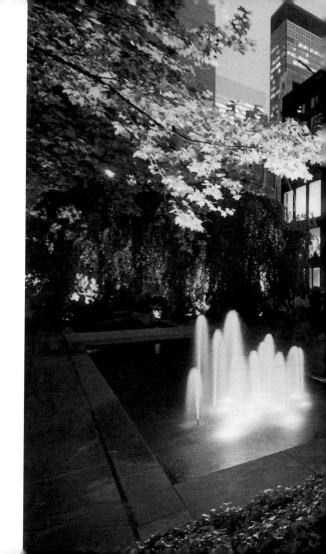

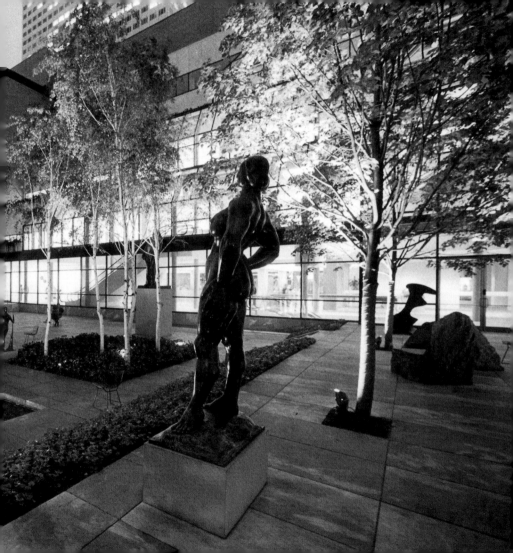

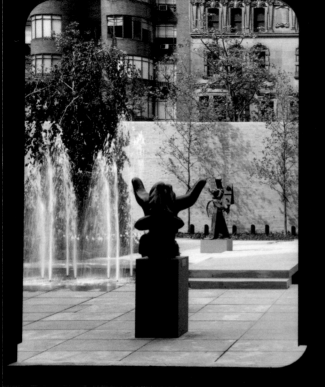

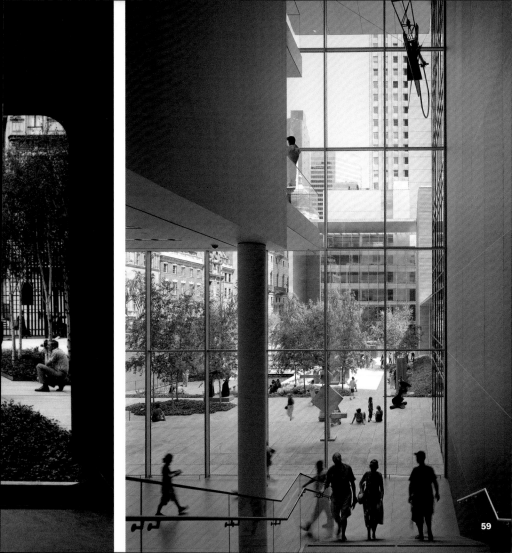

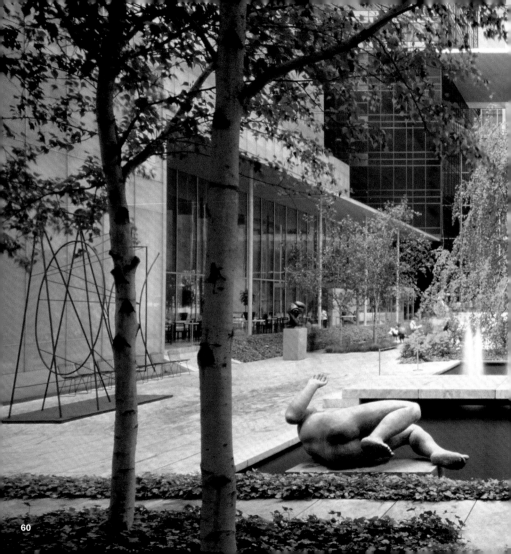

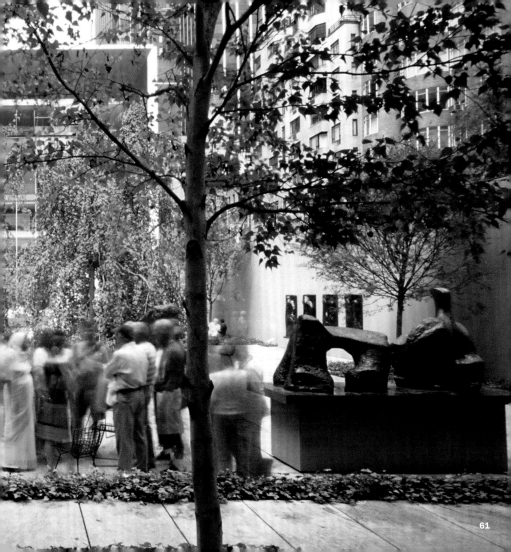

Captions

Cover: Aristide Maillol's *The Mediterranean* (1902–05)

Back cover: Looking east toward The Lewis B. and Dorothy Cullman Education and Research Building, 2006

Frontispiece: The Museum and Sculpture Garden from the northwest, 2006

p. 4: Scott Burton's *Pair of Rock Chairs* (1980–81)

p. 6: Looking east toward The Lewis B. and Dorothy Cullman Education and Research Building, with Scott Burton's *Pair of Rock Chairs* (1980–81) in the foreground and Tony Smith's *Die* (1962; fabricated 1998) behind, 2006

pp. 8–9: LEFT David Smith's *Cubi X* (1963), 2004; RIGHT Looking west, with Hector Guimard's *Entrance Gate to the Paris Subway (Métropolitain) Station* (c. 1900), 2006

pp. 10–11: LEFT Looking west toward The David and Peggy Rockefeller Building, with (left to right) Mark di Suvero's *For Roebling* (1971), Claes Oldenburg's *Geometric Mouse, Scale A* (1975), Tony Smith's *Die* (1962; fabricated 1998), Aristide Maillol's *The River* (1938–43), and Joel Shapiro's *Untitled* (1989–90), 2006; RIGHT Looking southwest, with The David and Peggy Rockefeller Building on the right, 2006

p. 12: Henry Moore's *Large Torso: Arch* (1962–63)

p. 15: Elie Nadelman's *Man in the Open Air* (c. 1915)

pp. 16–17: Looking east in 1964 (left), and in 2006 (right) toward The Lewis B. and Dorothy Cullman Education and Research Building

p. 18: Polygnotos G. Vagis's *The Snake* (1942)

p. 21: Aristide Maillol's *The Mediterranean* (1902–05)

pp. 22–23: Aristide Maillol's *The River* (1938–43)

p. 24: View of the exhibition *Shigeru Ban: A Paper Arch*, 2000, with Alexander Calder's *Black Widow* (1959)

p. 27: Looking west, with the garden's signature wire chairs designed by Harry Bertoia, 2006

pp. 28–29: The garden in summer 1964

pp. 46–47: LEFT Detail; RIGHT Looking northeast, 1987

pp. 48–49: LEFT Gaston Lachaise's *Standing Woman* (1932) in an installation from 1987 (left), with Jacques Lipchitz's *Figure* (1926–30; cast 1937) to the left of the pool; RIGHT Lachaise's *Standing Woman* in 2006, with David Smith's *Cubi X* (1963) behind it

pp. 50–51: LEFT Aristide Maillol's *Spring* (1910–11); RIGHT Snowfall, 1953

pp. 52–53: LEFT Scott Burton's *Pair of Rock Chairs* (1980–81); RIGHT Ellsworth Kelly's *Curve, II* (1973)

pp. 54–55: LEFT Pablo Picasso's *She-Goat* (1950; cast 1952) and Aristide Maillol's *The Mediterranean* (1902–05); RIGHT Picasso's *She-Goat* and Alexander Calder's *Black Widow* (1959)

pp. 56–57: The Sculpture Garden at night, with Gaston Lachaise's *Standing Woman* (1932) and view of Cesar Pelli's Garden Hall, 1990s

pp. 58–59: View from interior in 1964 (left), and in 2006 (right)

pp. 60–61: Looking west, with Pablo Picasso's *Monument* (1972) on the far left and Henry Moore's *Reclining Figure, II* (1960) on the far right, 2006

Credits